BELLINI IN ISTANBUL

BELLINI IN ISTANBUL

POEMS BY
LILLIAS BEVER

TUPELO PRESS
Dorset, Vermont

Bellini in Istanbul
Copyright © 2005 Lillias Bever
ISBN 13: 978-1-932195-26-2
ISBN 10: 1-932195-26-2
Printed in Canada

First paperback edition November 2005
Library of Congress Control Number 2005903086
Tupelo Press
PO Box 539, Dorset, Vermont 05251
802.366.8185 • Fax 802.362.1883 • www.tupelopress.org

Cover and text designed by Howard Klein

Tupelo Press is an award-winning independent literary press that
publishes fine fiction, non-fiction and poetry in books that are as much
a joy to hold as they are to read.

Tupelo Press is a registered 501(c)3 non-profit organization and relies on
donations to carry out its mission of publishing extraordinary work that
may be outside the realm of the large commercial publisher.

ACKNOWLEDGMENTS

Grateful acknowledgment is made to the editors of the following journals in which these poems first appeared, at times in earlier forms:

Gettysburg Review: "Cesarean" and "Tools"
Kalliope: "Ceramics Analysis" and "Excavation Dream"
New England Review: "Miracle at the Bridge of San Lorenzo"
Pleiades: "Fragment #5"
Poetry: "Mehmet Sniffing a Rose"
Prairie Schooner: "Aubade"
Quarterly West: "Ezan" and "Horse"
Seneca Review: "Statue"

"Ezan" and "Sapphic Fragment" appeared in *Pontoon: An Anthology of Washington State Poets* (Seattle: Floating Bridge Press, 2000).
"Cesarean" appeared on *Poetry Daily*, April 15, 2004 and will appear in *Literature and Society: An Introduction to Fiction, Poetry, Drama, and Non-Fiction* (Upper Saddle River, NJ: Prentice Hall Inc., 2006).

I would like to thank Artist Trust and the Seattle Arts Commission for their encouraging support. I wish also to express my particular gratitude to Carroll Bever, Raphael Dagold, Garrett Hongo, and Michael Collier.

for Phoebe

Contents

EXCAVATION

BELLINI IN ISTANBUL

EZAN

EXCAVATION

...even the ruins had been destroyed...
—JULIUS CAESAR, ON FIRST SEEING TROY

HORSE

It is how we imagine an idea to arrive:
suddenly, miraculously, out of the invisible
nowhere that makes up the boundary of our lives,

part fire, part wood, saddled in the smoke
of the other world. At the gates of the city
it just waits, eyes reflecting the blue indifference

of the sky, rolling with clouds, hooves
planted in the earth, so breathtakingly lovely
a sigh rises up from the populace, a figure of grace

with a hollow destruction inside. Resist it and the snakes
of the mind will rise up to strangle you; call to it
in its own language and you will be answered

by silence. Roll it in past the gates, let your hands
pass blindly over its flanks, listen with your ear
for the neck's hot pulse—you have been given a gift,

vouchsafed a dream—as the minutes tick by it waits,
standing between the moment of its glad reception
and the moment when the warriors

poured out, between its own myth
and what we later came to call it:
a siege-engine, an earthquake.

Sapphic Fragment

in your sky-blue shirt
[]

I couldn't look [
pierced by [

*

You are ugly, yes, and limp
badly, [
You have a horrible temper [
[]

*

To what shall I liken you?
Most of all you are like a bulldog, some battered oak tree

*

[]
] all night long [
] sleepless, I [
[]

*

And morning comes like a silvery reprieve [

AUBADE

Waking beside you in your apartment in Queens
I see books casting shadows
on the Oriental carpet,
the answering machine blinking messages
you never stopped to hear last night
when we stumbled through the door.
The night comes back in pieces:
you walking down Broadway
waving your arms, small flatteries
at the restaurant, how you were impolite
to the taxi driver from Guatemala
just learning his way around this city.
I am wondering what it would be like
to be married to someone like you,
what makes me shudder
for your hands as you shift half-awake
this morning, hands I don't know,
that aren't particularly careful
with the skin on my arms and throat.
The summer I turned thirteen
I started reading Tennyson, moved
by Elaine and her foolish love
for Lancelot, how she "bathed
his fevered brow," pining for his hands.
That was the same summer my brother's friend
lured me into cellars, into attics,
where I'd pretend to be asleep
so he could kiss me awake. Like Sleeping
Beauty, he claimed, stroking my face.
But I had read the old French version
and knew she ended by eating her children,
love's first kiss

waking in her something more than hunger.
I know the way a word can bruise
like kisses, and I know how difficult
it is to speak, breath catching like knives
as now when I test the sole of one foot
against the bare floor, hoping
I can unfold myself from the bed
before the scarf of his voice snaps out—
What is it that sleeps in the throat?

EXCAVATION: DESK DRAWER

What would you like to know?
I'll tell you everything.

———

The layers upon layers of revelation.

 notes to
 an unfinished novel, tiny
 passport photo,
 blank stare [*unreadable*]

———

Working from
pure conjecture,

 stray button []
 black comb with
 hairs still woven into its teeth

making quick successive digs,

 pens, paper clips,
 letter stuffed full of
 poems

my mind a delicate
and insistent tool—

draft of a syllabus,
"A History of Ottoman Love Poetry"

Seductive
course description
[crossed out]

———

How shall I conclude?

These things that could not in the end
tell me what they were,

torn pages from a diary
in a long looping Arabic script
[untranslatable]

which simply remained,

Black ink []

separated from one another
by little spaces

Pushpins []

White-out []

[text breaks off]

STATUE

It was a kind of suffering,
his hands forging my body,
sculpting cool ivory into fluid shapes

that moved and spoke without me,
nudes ascending and descending,
each one a possible end to the story:

a pair of gold earrings in the bathroom cabinet,
a red hair on the pillow;
headless torsos, a marble hand

grasping at nothing. *No form
without content,* he'd say,
as he bent over me in the darkness,

letting his left hand roam over me
in scholarly ecstasy: gluteus maximus, majora, minora,
such heavy words for the loveliness of the body, like shackles

restraining a freedom of movement; except
I wasn't free to move
without language to order my movements.

I, who without will, without volition,
had slept in the darkness
with only my irregularities to commend me,

a kind of potential, was now
a dream taking shape,
an idea struggling to the surface:

an end to possibilities.

CESAREAN

I.

There was an opera playing—
I remember that—
so beautiful, a modern piece sung by a woman
whose name I would never remember,
although the surgeon spoke it once, softly,
through his mask, and I strained to hear
past the clatter of implements on silver trays,
the bustle of the scrub nurses,
the murmurs of the anesthesiologist holding my head,
his tray of gauze strips fluttering like prayer rags—

II.

They'd pinned my arms down
like a butterfly's wings;
I had no feeling from the waist down;
a dreaminess took hold:
and the woman's voice kept wandering
in and out of the minutes, pulling
my mind after it, the notes
stretched so far the words had become
unintelligible—

The light was as bright as the sun
over an excavation site;
they were cleaning the area,
taking up their tools—

III.

Down and down through a slit

in the world, earth
falling away on both sides, past
history, botched experiments, sepsis,
Jacob the pig-gelder begging permission
to cut open his wife
in labor for three days; past
legend, Caesar cut whole
from his mother;
and deeper still, myth: Bacchus
slit from Zeus' thigh,
Athena bursting fully armed from his head,

as whatever is unmothered, torn
from its context, becomes
holy—

IV.

Jars, funeral urns, broken pieces
of pottery still glazed with their lovely enamels,
necklaces of lapis and ivory, gold
crowns encrusted with dirt, the mound

of the ancient city, and the mind,
sharp as the pig-gelder's knife—

V.

There was something in me;
I'd felt it for such a long time,
and now they were digging to find it,
but not like an archaeologist finding
the glint of something precious
in the earth, no, not as gentle
as that freeing, with its brushes
and soft cloths, more like

a robin tugging at a worm
stuck fast in the earth,

pulling with all its weight—

VI.

On the plain, the tumulus
swollen with artifacts; in the distance
men bending and cutting, digging
then pausing to lean on their shovels
in the hot sun, sweat pouring down their backs;

from where I was, it did not look
like delicate work, more like
hard labor: burnt grass, a broken wall
or two, goats grazing
casually in the shade, and high up in the trees

that ceaseless singing—

VII.

At last they found what they were looking for.
I heard a voice ask, *What is it? What is it?*
They were cleaning something, holding it up to the light—

In the Field

Excavation Dream

As if the book she was reading
 was burning, as if her eyes

were fire, or as if
 the steps of the staircase she was climbing

crumbled, one by one,
 behind her, and she must not look back—

so her gaze
 destroys what it falls upon,

each layer ruined
 in order to reach the next,

skeletons crumbling
 even as they are lifted,

fragile finds
 so deeply imbedded in their contexts

they turn to dust in the hand,
 leaving behind

only the faintest of stains—
 So how shall she proceed?

For how will the world ever bear
 her looking at it?

Tools

Teaspoons, dental probes, scalpels, ladles,
spoons with bowls bent back at an angle,
sometimes, picks; blunt penknives (which can be
surprisingly gentle); a hand brush
to reveal new layers (a subtle
instrument); a small wooden toothpick
for the most fragile of objects;
and the fundamental trowel,
whose point can be used to scrape or chop
or dig, which can clean a surface
with millimeter accuracy—
as familiar as a second hand,
operating delicately or
strongly as circumstances dictate.

Second Dream

In darkness she is groping on her knees,
 her hand reaching far

inside an empty place,
 fingering the silky valleys of dust, the backs

of rocks like mountains;
 all out of proportion she strokes

a whole landscape
 inside the texture box her mother has made her,

filled with roughness and softness,
 yarn, sandpaper; sharp and blunt objects

she must guess at, buttons, needles;
 the way, in darkness, familiar things

become strange, or rather,
 are restored to their true natures—

and the sensation racing up her arm,
 of what? Fear? Hope? The shock

of the world when she was a child...

Artifact

Here are its handles, and a belly
to store water or wine; here, a flight
of small ridges, like stairs, ascending
its spine, for candles perhaps, or flasks
of oil. Is it a vessel? A tool?
Along its sides, grooves like linear script,
or fingermarks where the clay wore thin…
She can see two eyes, or holes for air,
and a kind of nose, pinched in the clay,
and what looks like a long fluted gown
that flares outwards to make a platform
on which it stands, looking out at her
with its holes-for-eyes, and pinched clay face,
from its niche in the wall. She can't tell
its function, if it guides or protects.

Third Dream

She is flying over the site—
 so high, the country below could be

her birthplace, with its
 hills and burnt meadows, its sea

worrying and worrying a ragged coastline,
 making little inlets that race

inwards, as if trying
 to split the land apart—

she follows one now, rushing giddily
 forwards (or is it backwards?)

closer and closer in
 until she sees a stranger—no—it's herself

cradling something sharp in her hands,
 fingering its

jagged edge, murmuring,
 yes, this is where the break occurred—

Ceramics Analysis

From nicks and scratches on a vessel
she can trace its life, how it was used
to hold or pour liquids, wine, water—
and the place, worn thin, where hands gripped it
by its ear-shaped handle, the small chip
where it perhaps survived a fall, but
bounced to live again—to her, gorgeous
with use, even more than, or despite
its design of underwater life:
fishes and octopi in black paint,
seaweed, fins, spiraling tentacles
weaving and interlacing across
its surface: a submarine vision
she thinks of now, looking down
at her submerged self, which once held life—
tracing across her belly, her thighs,
the use-marks, fluent patterns of wear.

Last Dream

A chorus of voices—no, a tree
 full of birds—but more broken than that,

more like a single bird's tentative
 song, heard fitfully and far away

before the light—these jagged patterns
 she must try to match: triangular

slice of urn, piece of fluted column
 or bright drapery across a leg,

a surface covered in mazy cracks,
 with lines of breakage so fine it is

hard to see how they connect at all…
 in her dream, she bends over a heap

of angles so oblique meaning slips
 off them—their edges shining as if

they adhered only to air, and light.

THE TOMB OF THE WEEPING WOMEN

In the darkness of the museum,
the lines of weeping women:

> the head-in-hands,
> the bent-back, hands-folded-on-lap,
> the pensive thinker
> > toying with her veil,

> the violent
> tearing-her-hair, beating-her-breast.

O sad women!
Each alone in her own chamber,
separated by a row of columns,
seated on the same
> low, simple ledge.

> Found in 1887
> by a peasant ploughing his field:
> the tomb of Saydian king
> > Straton,
> dead in 360 B.C.

———

Here were the shapes the future
> held out to me—
in the darkness of the museum,
where I was trying to align myself
with these forms, in order to understand them,
bending my back, bringing my hands to my face,

it had been such a long time
since I'd wept,

Standing before the tomb of a king,
before the frieze of women weeping, a seemingly
endless procession of women, leaving
in their wake a trail of invisible tears.

Why are they weeping? I asked myself
in the unbroken silence of the museum,
walking around and around the sarcophagus
like a man in his field, where
among the half-ploughed furrows, a story
struggled to the light, barely

brushing the surface of the ground—

———

Why are they weeping?
I asked. *Best not to ask,*
he replied, from the other side of the room,
where he stood
studying Alexander's tomb, the blood-thirsty

conqueror king, whom Fortune loved.

Just a stray touch
cold as stone,
then the shiver of apprehension—

a festival, a procession, a battle,
a hunt,

something searching me out,
coming to light out of the darkness of the field,

the eye beginning,
then—begging, to be caught,

and this is how it works, isn't it?
Coming to you only
when you're ready for it,
first a shiver, then
a punch in the gut,
the mind
needing to pattern itself after
the thing, before it can be perceived—

———

Why are they weeping?
I asked. *Best not to know,*
he replied, wishing to spare me,
but there was a boundary-line, something
that was beginning to be made clear,
revealed unveiled,

Something to know, to be
found out, so many
nameless, faceless women

like seeds for the planting,

so willing to be seduced,
to lose yourself, for one long moment—

———

Knowledge,
 like grief, makes its own inscriptions on the mind,
 permanent
 furrows, casting their own
 little shadows—

Shrouded & veiled

were the shapes the future
held out to me,
and I stood watching them,
cold as stone, who would become
 each one in turn,
 in time:

 the head-in-hands,
 the pensive thinker,
 even the violent
 tearing-her-hair.

———

 Women, why are you weeping?

In the museum,
where sleeping thoughts wake,
I saw no king, only
each woman closeted with her own grief,

 making each
 a universe of weeping—

Beautiful, yes, but I was
unmoved by them, as the king
whose dust they graced,
so monotonous, one after another, the old
familiar gestures of grief,

 the heavy plough, the wheels, hooves
 plodding back and forth, back and forth,

thinking to myself,
 O women, look up. You are
 stele decorating a tomb.

 Above you pass
 the centuries,
 stately, & slow.

———

You see, I was not yet willing
to see, I preferred
 the inbetween
 of these rippling shadows, of figures
 taking their places, their veils
 almost transparent,

seating themselves in their
accustomed chairs,
 their accustomed
 gestures, but not yet, not yet—

———

I was still free,
only my eye just beginning to be caught

 by this subtly-patterned,
 delicately-carved frieze

 like the ploughman, who must have stood
staring hard into the darkness of his field,
not yet willing to see what his eyes told him,

 for a long, long time

 unready to wake.

BELLINI IN ISTANBUL

*True art is to create a glorious city. And to fill the people's
hearts with felicity.*
—MEHMET II

SIGNS AND PORTENTS

An angel is reading the book of History, whose pages
are lit by a holy fire. The angel is the sun
bending over the earth in the fifteenth-century darkness,
in which one city of the earth is being consumed
by a ravaging red fire—Mehmet the Conqueror
breaking into the holy city of Byzantium.
The priests vanish behind the altarpieces
of martyred saints, clutching
their precious images, as Mehmet bends from his horse,
letting his fingers brush the city wall as he passes
through the Adrianople gate. In three days
he will brush his forehead with earth and enter
the church of the Holy Wisdom, wash
the blood of the slain from the marbled floor—
red and gold and holy green, he will take his place
like the bee at the center of the tulip.

CALLED TO THE OTTOMAN

In 1479, after sixteen years of war,
 an uneasy truce has sprung up
 between the two republics:

Venice, most powerful of the Italian states,
 and Istanbul, new capital of the Ottoman Empire
 and scourge of the Western world:

European monarchs are urged to launch
 a fifth crusade: the Pope, the Holy Roman Emperor,
 the King of France; the Sultan is surrounded

by foes: Hungary, Austria, Genoa—
 Venice alone has made fourteen attempts to poison him.
 When, in this dark time, a Jewish orator from the Lord Turk

arrived with an invitation to a wedding, and a request
 for "a good painter," the Doge, declining
 the invitation, complied

with the request; and in September
 Gentile Bellini, son of Jacopo,
 brother of Giovanni

and official painter of the Venetian Republic,
 took passage aboard a Romanian galley
 and watched the Serenissima dwindle into the mist;

as the silver sweep of the Adriatic opened before him
 like a vast canvas
 on which nothing is written, but light.

SCENES FROM A SKETCHBOOK

Horses prancing in sunlight,
 their legs lifting in successive fluid arcs;
a couple seated cross-legged on the ground,
 the man with his hands on his hips,
the woman delicately holding up
 a mirror; in the Hippodrome,
the column of Theodosius
 covered with carvings
of an antique battle
 between worn figures in stone—

shapes hidden and revealed:
 shadow, pockets of sunlight,
and textures: stone, steel, hair, flesh;
 a Turk on horseback,
his sword and helmet gleaming,
 a woman bending, lifting aside her veil…

in Galata,
 an ordinary street-corner scene:
horses unsaddled, cropping the grass;
 two seated men in turbans,
one holding a falcon;
 a third a way off, his chin in his hand—
faces lifted in sunlight,
 domes, open porticoes;
the shape of a leg,
 columns from a church;

slaves at the market
from Circassia, Rumelia, Georgia,
a hundred fine girls in costly apparel,
a thousand fine boys with radiant faces;
a dervish singing, mounted on a bench;
a dervish whirling, head tilted, his arms
a sharp diagonal between earth and sky;

the city, like the human figure, reducible
to planes and angles, circles and lines,
rectangle and square and octagon:
inns and warehouses, baths and bazaars,
sick-houses, synagogues, cisterns,
palaces and caravanserais;

from the top of Sultanahmet,
a bird's eye view
of air and light and shadowed places,
covered markets, alleys, and rooftops,
from which, here and there,
the domes of the mosques rise,
their minarets
a thousand fingers pointing up to God.

MEHMET SNIFFING A ROSE

It is an unlikely pose:
 in this portrait, copied
 by Sinan from the lost original,
the Sultan, described by contemporaries
 as hawk-faced, red-haired,
 "of an aspect inspiring fear
rather than reverence,"

 is evaluating a rose:
 nostrils
delicately arched, lips
 pursed, eyes lost
 to the horizon—

this man, who favored
 careful decapitation of his victims,
 strangulation, impalement,
who had the son of Constantine's chief minister
 slaughtered before his father's eyes
 because he had refused to give the child over
to the Sultan's pleasure—

 is nevertheless
 holding the rose delicately,
between his fingertips,
 such a frail thing,
 but he appreciates its nature;
and in his mind makes a metaphor
 between this rose
 and the life of man:

kingdoms bloom and fall,
 releasing their perfumes:
 beauty, terror,
bloodshed,
 new palaces on top of the old,
 as the bones in the graveyards
stir—so the petals of history
 unfold, one by one,
 at the center,
a bare stalk:
 a few thorns, torn leaves.

 Mehmet,
bastard son
 of a slave girl and a sultan,
 who taught himself Greek,
Latin, Persian,
 who scribbled
 verses—

Mehmet, called
 Fatih, Conqueror,
 is sniffing a rose,
savoring its scent: that is to him
 like poetry, Greek logic,
 like the fields outside Vienna
in springtime,
 like Europe, like the sweet
 necks of princes.

AFTER NATURE

Mehmet leafs through a folio of paintings,
 finds a picture of John the Baptist
 his head severed, on a plate—
 his beautiful neck
 cut cleanly, his face
 holy even in death.

Mehmet stares in silence,
 then offers a critique:
 the neck is projecting too far
 from the head; it would have disappeared
 because of the contraction that is produced
 in these cases;

and in order to let the painter judge, "after nature,"
 the justice of his observations, calls
 in a slave…
 As if words could come true,
 as if a painting were not a reproduction
 but a tiny piece
 of world—

a broken-off piece
 of God's own creation, in which
 terrible things happen:
 babies are slaughtered and their mothers
 enslaved; in which
 husbands do not return from the battle

or worse, return
 with pieces of themselves missing,
 pieces that can never be filled,
 but remain empty,
 holes through which to peer
 into a black void—

A man is going to be killed.
 He kneels, he begs for his life:
 and the blade is raised above him
 the shining, glittering blade
 the brush joys in,
 that language longs to make a metaphor of,

the blade is rising,
 falling, severing
 flesh from flesh, bone from
bone—
 In the noiseless hushed room

the head is falling, rolling
 away
 the eye looks back at
 the neck stalk, the empty
 place where the head used to be

 and (yes) the flesh is shrinking,
 and (yes) the neck retracting,
 and in that blackness Gentile sees
 nothing but the reflection
of his own, terrified gaze:

...in order to demonstrate the effects
of decapitation

 (once separated from the trunk
 the neck retracts also)

the slave kneels before them,
head bowed
 almost to the ground;
 he is young, he is shaking,
even the curls on the back of his neck
 are trembling. . .
 (gently) (noiselessly)

Cose di Lussúria

In the inner chambers
 of the Seraglio, where no foot
is allowed to step
 except the Sultan's,
and the servants he favors
 with a summons to his imperial service;

asked to paint
 "cose di lussúria,"
luxurious things;
 baffled by how to begin,
by the request, "erotica,"
 the Sultan's white hands

waving vaguely
 as if to describe
the female shape;
 Gentile paints
the only woman
 he has ever known:

the Madonna,
 her sweet face
lit up by candles
 on altarpieces
all over Italy,
 he undresses her:

lifts the veil,
 takes off her robes
slowly, one by one,
 caresses

with rosy paints
 the thighs,

shadows
 the stomach with fine hairs,
thrusts the white neck
 back, closes the eyes,
parts her lips
 as if to speak.

Young Man Drawing

Cross-legged, holding a reed
 in his right hand, he is writing,
 or rather, drawing—holding his breath,
 his hand sweeping across the page
in strokes that scroll and unscroll
 as light moves across the waters of the Bosphorus,
 unravelling its fluid indecipherable script
 like language making and unmaking itself,
speaking or appearing to have been spoken—

In the Nakkashane, the imperial workshop,
 the young man is drawing, or
 as some have seen it, writing,
 with the faint shadow of a moustache
along his upper lip, and a ring
 in his ear; in perfect concentration
 he bends to his task, grasping
 the pen loosely, between three fingers,
as the page fills before him

with letters that leap and swerve
 like the birds above the Bosphorus,
 or like the patterns that grow on his embroidered robe:
 golden arabesques of plants and vines
on a blue ground, that jump out
 like flames onto the wall behind him,
 where some verses of the Koran
 celebrate the words of the Prophet:
There is no god but God…

The young man writing is celebrating
 God, the beauty of the word, drawing himself

also into the picture (the patterns
of his robe, the curves of his turban,
the letters that leap on the wall behind him),
without making a single image
(though it tempts him, these loops and swirls
of an alphabet in which
animals hide and faces peer),

without transgressing the Koran
which forbids idolatry
(letters like the flights of birds, like vines,
like the waves along the Bosphorus),
he can still
trace the shape of the world's body,
in language that speaks of it—
dipping and rising, leaping and swerving,
lines that make the word possible.

Album of the Conqueror

Here is the world as we might think of it:
 beautiful, pocket-sized, in bright
jewel-like colors, something
 to hold and admire, to offer
 or to take away—

part map, part landscape, part
 imperial inventory: whole armies
and their encampments, lands conquered
 or under siege, tiny ships
 tilting on tiny oceans—

and fixed, two-dimensional, without
 scale or perspective,
masts of ships like minarets
 crowding up against mountain pinnacles,
 cities pressed into oceans, far horizons

infinitely touchable, infinitely
 graspable, a vision
reflecting the distortions of desire:
 leafing through his album of miniatures,
 Mehmet, patron of the arts, is master

of all that he sees—to which
 he now wishes Gentile to add "a Venice,"
kingdom of miracles, Queen
 of the Air and Sea,
 the mighty Serenissima

reduced to
 these church spires and shining squares,

festivals honoring the birth of the Virgin,
a city encircled by a wreath of waters:
Mehmet holds it in his hands.

SELF-PORTRAIT

After having Gentile paint many people
 whose beauty had pleased him,
 the Sultan, wishing one day

to test the painter's powers,
 makes one more request—
 So Gentile, unwillingly,

lifts a hand mirror
 to that most elusive of subjects,
 the most difficult sitter of all...

The Sultan, upon examining the portrait,
 was astounded, proclaiming
 there was some magic in it

somewhere, for this painted thing
 created by a human hand
 to appear so alive, and to breathe:

he sees a man, forty-odd years of age,
 plain, a little watchful,
 with lines around the mouth and eyes,

looking straight back at him
 with a level gaze, as if to say,
 have no illusions about what you see.

MIRACLE AT THE BRIDGE OF SAN LORENZO

This morning, the city rises
 shining out of the sea, shoulders
still dripping with sea-water;
 crossing the square at St. Mark's,
Gentile is glad to be home,

 glad to be on his way
to paint a miracle:
 at the Bridge of San Lorenzo,
crowds gather to rescue
 a fragment of the True Cross which floats

beyond reach on the pale green water:
 gondolas and ghostly figures
glide in the canal; a child
 dangles from the bridge; a black
servant prepares to jump:

 It is the kind of scene
Gentile excels at, full
 of detail, little incidents, bystanders,
less a painting of a miracle
 than a portrait of his beloved Venice.

Yes, he is glad to be home;
 but this morning, hurrying
along the winding footpaths
 and over the narrow bridges,
the wind off the sea

makes his eyes water,
the city trembles in his vision
 reforming in reflections
on the green canals:
 spires turn into minarets,

palazzos into palaces
 lined with arabesques of trailing
plants, animals leaping
 to embrace one another,
tombs like turbans in the floating graveyards;

 before his eyes, his own city
grows strange:
 a ghost city. A ghost of a ghost.
Something he can no longer
 put a brush to.

PORTRAIT OF THE CONQUEROR

As a woman lowers her veil, allowing
 herself to be seen, so
he has lowered his sultanness,
 that curtain of glamour:
 aquiline nose, short beard, moustache…

 As a woman pulls aside
 her veil, or as a rose
bends back its petals, one by one,
 so we can finally see the face
 in its expression of collapse, of mortal fatigue:

Shadows pooling
 beneath the eyes, shoulders
hunched, and the profile
 which, with age, has not softened,
 but sharpened, like the sickle moon

 the night he sent up the signal for the onslaught,
 and the people of the city heard
the deafening war-cries,
 the drums and trumpets of the Janissaries,
 loud as the angels of God—

As when a fully-blown rose
 bends back its petals, or as when
a city finally yields
 to its conquerors,
 so he, too, knew humility,

wandering through the ruined
 Palace of the Emperors, murmuring
lines by a Persian poet:
 The spider weaves the curtains in the palace of the Caesars;
 The owl calls the watches in the towers of Afrasiab…

twenty-one years old, upon capturing Constantinople.
 As when a rose, dying,
opens itself completely, so
 he has opened himself to the painter's gaze,
 an old man in whose face

 the spiders weave, and the owls call out—
 Already marked by that which
will soon strike,
 which, even now, hovers outside
 his territories, preparing for the assault.

EZAN

There is an Istanbul more beautiful than Istanbul...
—SAIT FAIK

IMPERIAL REFLECTIONS

He came at me
 Suddenly—the Thunderbolt, the Conqueror,
The Magnificent. Siege-engine,
 Battering-ram, cannonball,
He besieged me
 As a man besieges a woman.
I resisted, put up a fight: but
 He found a tiny niche in the wall,
& pushed in.

 Together we made a Kingdom.
There were Palaces built, & Places
 Of Worship; Plans & Projects
To expand into new
 Territories, to press
The limits of the Known—

 All this was Fated, & Pleasant.
All day long my mind lounged
 In its shady kiosk, while outside
Fountains plashed, & Animals roamed
 The Pleasure-Garden:
Camels & Elephants, the Gorgeously spotted
 Leopard, & shielded from the sun
By screens of muslin,
 My opulent
Tulips, tender as baby flesh.

 Our life was wrong, I admit.
He criticized my growing
 Lack of allies, my general indifference
To the World.

I reclined on a sofa
& sipped sweet rose petal Sherbet.
 Incense inflamed an intricate Poetry,
Born of Leisure & Isolation;
 I fed my Appetites, & grew Still...

Something has to change, he exclaimed.
 He'd taken to wearing his black shirt with
Its Revolutionary Collar, & grew
 A fashionable Goatee, which hid
His Mouth. I sat watching
 History pass out of his eyes.
His face was a Mirror in which
 I saw myself: ornate, self-involved,
given to hysterics & fits of over-indulgence...

 At last, *I no longer feel*
Romantically about you:
 The Death-Blow. But this
Is how it works, isn't it?
 First the Age of Glory, then of Gold, Time
Of Scandals & internal
 Corruption, the Decline
& Fall. Now

 I wander in dishevelment among
Apartment blocks, Hotels & Factories,
 The glittering High-Rises,
Quoting antique Verses, their lyric Phrasings.
 He looks
Straight through me, as if I were a
 Ghost, then hurries on. But since
Memory, unlike empires,
 Cannot die, I

Come back to him at every turn:
 Old indecipherable
Inscriptions on Fountains & above Archways,
 Set in ovals, like a shield, or mirror—
Beautiful
 & useless, the scribblings of Light on Water.

EZAN

In Bebek, a famous tenor calls
the ezan from Kemalettin's elegant, dove-grey mosque,

his voice spilling like noon light over the park.
It's Friday. The devout are washing

off the morning's dust, their shoes lined up
neatly at the lip of the public fountains.

There are the undevout: old men sitting in the sun
smoking and chucking the stray cats under the chin,

university students hunched over clear glasses of tea
nearby in the big shady café. Over all

the midday prayer breaks its impassioned benediction
tenderly, like a lover pleading, pleading

then pausing for five breaths, seven breaths, nine—
in which the world simply goes on with its business:

dogs bark, the bus for Taksim roars off in a cloud
of blue smoke, a young boy calls out, "Mehmet, Mehmet!"

clearly, like a bird. The tenor begins again, a sound
so lovely the mind unloosens, then a pause, as if allowing

the world to blossom before taking it completely.

THE KARAKÖY FISH MARKET

Over the Galata Bridge in darkness
the crowds are thronging,
as sunset seeps away into the Horn
and night rises up on all sides
from where it had been hiding
among the crooked streets and in the mosques
ringed with lights for Ramadan;
past wind-up toys, airplanes, cigarettes,
blue jeans and alarm clocks,
shoeshine boys, simit sellers, bathroom scales
set out as if to measure the weight of each weary day,
past beggars holding out their hands
people are hurrying:
while on the far side the twinkling lights
of the fishing boats nudge the pier at Karaköy,
and fishermen in long white aprons
are calling. In the distance
ferryboats ply their way between
Eminönü and Üsküdar
lit up with lights like wedding cakes—
heading off between the arms
of Europe and Asia, that reach
out into the darkness of the Marmara Sea,
almost touching, but never quite,
separated by the churning currents of the straits
whose waters pull first south, then north.
Over the bridge, at the fish market,
everything is as clear
as belief: the fish laid so gently
next to one another one hesitates
to separate them, their mouths slightly agape
like children sleeping—

and how their shapes echo beneath the blinding bulbs,
their shining numbers—stall after stall,
layer after layer—speak
of what we might still expect to receive
from darkness, we who throng
the bridges at nightfall, crossing
and recrossing the straits that divide us.

Man in an Oriental Costume

We'd seen so much of the world that day
our eyes refused to take in any more:
the gardens and palaces, the luxurious
gilded bedrooms of the Sultan and his retinue,
the tiny yard where the women of the harem
tied back their hair and kicked golden balls to one another.
Now, we've crossed back over the Galata Bridge
and into Beyoğlu, where our footsteps ring out
on the dark winding streets like the chimes of a clock.
You are not looking at me. All around us rise
the signs and symbols of a changing culture:
posters for the GAP and Banana Republic,
teenagers laughing and smoking down by the water's edge,
wealthy women in Gucci and high heels
clutching their tiny handbags.
Still, there are the very poor: gypsy children
selling packs of home-made Christmas cards,
workers in the kitchens of the famous restaurants,
all the things that are difficult to see,
and then, more difficult to speak of.
You are walking straight ahead,
I, a few paces behind, where I can still see you
swinging your arms, disappearing
into a crowd of people that are, after all, to you,
not strangers. I
am finally on my own in a foreign country:
I am learning to see what I can
without you, as in this painting by Rembrandt, a portrait
both true and not true, as all
such depictions are;
the way we work to keep our vision clear
of the shadows creeping across it,

as real as the evening shadows now falling across Taksim Square.
It is a face I know: the broken mask of flesh, the heavy eyes,
even the flecks of light shining like gold in the darkness;
and now, I can only imagine what you saw
when you turned to find me
not there: footsteps, echoes, diesel smoke, the late
afternoon sunlight of another country.

NIGHT VOICES

I know something about history
and its repetitions, rippling
like sea-water across sand,
leaving its marks, its tideline sediments.
Each night I told you
a different story, or else
the same story over again,
it didn't matter: you were listening for
the invisible meshing between parts,
how A led to B led to C,
the crisis, the inevitable dénouement.
Your own life was full of gaps and shadows:
a last name plucked
from a pomegranate tree, an ancestor
felling trees in Black Sea forests,
rolling timber down rivers,
reduced to selling watermelon on dusty city streets;
your grandfather and his four wives
no one could account for,
their voices like wind or water.

In your novel I'm split into parts
like a Picasso painting,
nose, eyes, mouth, *entirely unrelated,*
my eyes in a different face,
my words coming out
of another mouth, a voice
telling stories, my stories:
fluty, foreign,
like splashes of warm water.
On our thousandth and first night,
I could tell you a story

that holds all the parts together,
that made the rest of you come true:
the day the last Sultan opened the palace doors
and the women of the harem
walked out into the 20th century sunlight—
your grandfather choosing carefully among them.

In the Treasury of Swords

Tribute Sword

My hilt was fashioned in Samarkand,
inlaid with Indian emeralds and Persian gold.
My scabbard is of parrot's beak.
With my hand-painted girdles
set with glittery diamonds, I'm lovely.
I can see myself reflected in every mirror.
My desires are aesthetic;
I've never tasted blood.
But handle me with care: I'm sharp
with idle luxury.

Janissary's Sword

I've slain six viziers, three pashas, an aspiring sultan.
I've a majestic heft: a weight I'm proud
only the strongest hands can bear.
Victory's mine, I never fail—
I swagger to the mehter's trumpet and drum—
See these two jeweled balls
on either side of my hilt?
After I've plunged
as far as I am able, I feel them ring.

Harem Sword

For years I rode the chief eunuch's
silken hips. What he could not deliver

I gave for free. Steam misted
my blade, I cut the perfumed air—
when the women saw me
dance, they cried
out loud and tore their hair.

Executioner's Sword

I'm stately and precise.
I adore a ritual.
To execute something well
is my greatest delight.
If life's a play, I see it through
to the final act: the heads
roll, the crowd roars—
afterwards, I take a bow
in the cool waters of the fountain.

Dessert Knife

I was stolen from a sherbet tray.
She keeps me close. I can feel her breathe.
Her skin smells lovely, like a rose
at the moment of its opening—
I could live here forever, in the nook
between her breasts.
I know she has a plan for me.
At night she touches
my blade, strokes its modest length.
Murder, revenge, self-
protection, I don't care—
I'd do anything to stay
close to her pounding chest.

Jeweled Scimitar

What do you see in me?
Do you think I sleep
the sleep of the innocent
inside my dark red velvet case?
The slave spent hours
trying to clean the blood
off my handle: répoussé work engraved
by hand, emeralds and diamonds
set within their stone compartments,
and at my handle's tip, the stopped
clock with the ruby lid
that had carefully counted down the moments.

Small Knife

Palace politics. I do the dirty work.
I know what it is to be a slave.
I know I'm plain: I'm kept inside
the palace guard's leather boot,
snug against his hairy ankle.
Assassinations, conspiracies,
I've played my petty part—
but this last time something changed.
The girl was cornered, stared
transfixed as I leapt flashing out
then clattered to the pavement stones.
No one knows the role I took
at the final moment: how I broke
myself in two, and saved her.

THE ALEXANDER SARCOPHAGUS

The light here is dim. On each side
it's almost possible to make out
the forms of men fighting men, men

fighting lions or leopards, naked
or clothed, swaying, thrusting, like question
and answer, the old language of slash and recoil.

Closer. There's a story here.
It's the conquest of Asia. And the figures
are now divisible into two separate armies:

the Persians, sandaled and gowned, with only
their eyes visible through the slits of their veils,
and the Macedonians, muscular, heroic, utterly naked

except for their helmets and shields.
From a distance it would appear to be
just forms fighting forms, hidden

or revealed, making in themselves
an intricate beauty, touching each other
in the only way possible.

The Persian Empire is dying.
Something brutal is being born, the world
will be unpredictable and violent—

At left, Alexander
leaps in like a lion,
his cape flying behind him—

On the fourth side, a Macedonian
raises his blade against that which appears
to defy him, a kind of hiddenness, while a Persian

half-crouches, shielding his face
from this new, naked, utterly destructive spirit
slashing and slashing at his invisible veils.

CATALOGUE

A sickle-shaped cove
where waves rush over the pebbles,
falling and pulling back, falling
and pulling back; rocks
with their hair
floating on the water,
neckless and armless,
glittering with barnacles;
a tideline of borders given
and taken away again, old
animosities,
new unstable alliances,
loans and paybacks
as the sea
murmurs its continual assent

These are beautiful parts
of the world

Bullets that collide
in mid-air,
broken tobacco pipes,
a shoe
with the foot still in it;
buttons,
boots, jaws,
empty belt buckles;
hardened chunks
of ration bread,
tobacco pouches, magazines,
a Koran small enough
to wear around the neck;

dog tags, artificial teeth,
a skull
with a bullet embedded in its forehead

I don't need
any underwear, don't send
any money

Greetings at three o'clock
from the enemies
on the front line, throwing
tobacco and chocolate across
with broken English, broken Turkish;
the slaughter on the gently rolling slopes
so close
soldiers lay embracing one another in rigor mortis
not to be parted:
Hakan age 19, Philip age 21;

Fresh mud on the open graves
in April,
sunflowers and blooming olive,
nightingales at evening,
heath and brush, poppies
red as fire

Mother, this is the world

STORM

This morning the world dawns luminous and grey,
the light along the horizon a darkening afterthought

as a storm rises out of the North on a Black Sea wind—
all along the Bosphorus the wooden fishing boats

rock like painted toys on the grey-green water
which is wild with white-caps, like dolphins' backs

rising and rising out of the swelling depths; gaily-colored junk
stirred from the murky bottom clings to the bank in clumps:

empty water bottles, shopping bags, a pink plastic slipper,
all the little things we let slip from our fingers

and in time, forgotten we'd lost. Now soon
along the surface of the water will come those skimming birds

that pursue the waves in wildly flapping, ragged V's,
alternately grey and white as the light hits them, like leaves

as the wind rises: birds that prefer to fly
when the weather changes, and just before storms: called

by city dwellers *current chasers,* and by sailors, *lost souls.*

FRAGMENT #5

the wind picks up the leaves and carries them

*

What I want, and don't want

*

the sea, so blue, a deep
porpoise-leaping blue:
tiny sails fluttering on the horizon
[]

*

My heart, like papyrus
tears easily, [

*

I can only think of you
in fragments
afraid to sink [
[]

*

] like a tidal wave,
but what shall I do?

*

] my little craft, trembling [
] the bright, empty, deep blue ocean [

INDEX ISLAMICUS

Pieces of history are falling out
and crumbling into dust between my fingers,
frail as the traces of a country
we stepped out of, walked away from
as lightly as one steps away from a book one's finished reading;

Travels in—
Facts and Fallacies of—

At dawn we'd seen the sun rise over the waters of the straits
and the gulls like restless spirits trying to come home;
but that night the road to Çanakkale was covered in snow,
and through little circles at the windows we saw
the land stretching out beyond, great uneven fields
of emptiness, but when the lights switched on
all that was left were the pale ovals of our faces,
staring back at us like ghosts
the snow had summoned up out of those empty fields;

Northern Frontiers of—
Hopes and Perils of—

By midnight we'd reached the Dardanelles, the place
where two seas tighten into a single churning throat,
but our crossing was easy, the water smooth
as glass under moonlight, the huge rumbling ferry
cutting its engine as it reached the far shore;

Wars of Conquest of—
Terms of Peace with—

The city we found was in ruins, layered like the tiers

of a wedding cake, and hunters were out shooting squirrels
in the bitter cold, and dry brush was growing out of the
	crumbling walls;
but just past the boundary line was a freshly dug shaft
where the earliest layers were showing themselves,
bones out of the earth;

Scenery and Antiquities of—
Sketches from Life in—

Then like a dream in which
I'd stayed too long, a last picture
glimpsed in the pre-dawn darkness
haunted me all the way to the airport:
a city bus filled with dusty, overtired workers,
crammed so full
one man was reaching his hands up to the ceiling
in a gesture of surrender;

and the East—
and the Eastern Question—
and Persia,
and Russia,
and England—

I think of how
we left a country behind,
bringing such a few things with us:
tea, sweet lokum, delicate silver-backed mirrors,
a small rug of a deep and permanent red color.

BLUE GUIDE TO ISTANBUL

The blue of early morning
and diesel smoke, of pollution hovering
in the hills above the Bosphorus

> the pointed shadows of the fountains,
> the blue cry
> of the ezan at dawn—

the blue of sea and sky, of boats crossing
and recrossing the straits,

> and the blue and white uniforms of the ferrymen,
> the ferries rumbling impatiently at the landing,

the blue domes of the mosques, covered
inside with Iznik tiles

> and palaces, gleaming marble
> by the blue waters of the straits;

The blue of entrance tickets,
passports, the uniforms
of the tourist police,

> the blue of the nazar boncuk, talismans
> against the evil eye
> outside shops and houses, pinned up in taxicabs,

the blue eyes of the woman
in the bakery at Kanlıca
who refused to look at me,

the blue of suspicion—

Glass and marble and blue carpet
at your parents' house
on Hekimler Sitesi,

 the blue
 of your father's paintings
 of sea and sky, the world
 in perpetual motion,

the Uzbek blue
of your mother's eyes inspecting
my dress, the rings on my fingers;

The blue-silver scales of fish
at the fish market,
blue parakeets in the cages
at the bird-market,

 the blue of desire—

Yogurt so white
it's almost blue,
the blue of the swimming pool
I wanted to disappear in,

 the blue of foreignness—

Blue steam in Sultanahmet
from the tops of the hamams,

the blue of Byzantine mosaics,
the blue face of Christ
at Aya Sofya,

blue tears of the disappointed lovers
in the miniatures,

 Mejnun crying out among the animals
 in a blue wilderness—

Wildflowers
along the highway
to Erzurum, and high in the Kaçkar
blue butterflies
in the alpine meadows,
and higher up, tiny poisonous blue berries,
the blue of the lake
we would not reach—

 the blue of possibility—

The blue of secrets,
and the small bruises
along my arm,

the blue ink of a journal
written right to left
in a fluid Arabic script
like the waves along the Bosphorus,

 the blue of betrayal—

In Istanbul
at the Ismail Aga Café,
blue shadows beneath your eyes,
the blue veins on the back of your hands
cupped around a tulip-shaped glass

of tea, smoke
from passing busses and trucks

rising, fading away into the air
of another, impossibly clear morning,

 our last, though everything
 around us was blue, still blue—

NOTES

"Sapphic Fragment" and "Fragment #5": The form of the translated "fragment" (complete with asterisks and brackets) was inspired by Jim Powell's translation of Sappho *(Sappho: A Garland)*, Heather McHugh's essay "Broken English: What We Make of Fragments" (in *Broken English: Poetry and Partiality)*, Victorian imitations of Sappho and contemporary poets' rendering of ancient fragments, including Sidney Wade.

"Excavation Dream" and "Tools" take some phrasing and archaeological terminology from Philip Barker's *Techniques of Archaeological Excavation*.

"The Tomb of the Weeping Women": c. 350 B.C., Istanbul Archaeological Museum.

"Bellini in Istanbul": Poems in the series are based on accounts of Gentile Bellini's sojourn in 1479-80 at the court of Mehmet the Conqueror, where he painted portraits of contemporary Turks and Ottoman court life, including several of Mehmet himself. Many of these paintings were later lost after Mehmet's son Bayazit, upon assuming the Sultanate, sold them in bazaars throughout the city. Recovered works attributed to Gentile include pages from his sketchbook, a painting, "Seated Scribe," currently in the Isabella Stewart Gardner Museum in Boston, and a final portrait of Mehmet II, now at the National Gallery in London.

Stories and legends about Gentile's visit and descriptions of Ottoman-age Istanbul borrowed, adapted, or inspired by the following sources:

Mehmed the Conqueror and His Time by Franz Babinger; "Gentile Bellini" by H. Collins (Ph.D. dissertation, University of Pittsburgh); *Venetian Narrative Painting in the Age of Carpaccio* by Patricia Fortini Brown; 'The Development of Gentile Bellini's Portraiture' by Creighton Gilbert in *Arte Veneta*, xv, 1961; *History of Mehmed the Conqueror* by Kritovoulos; *Istanbul and the Civilization of the Ottoman Empire* by Bernard Lewis; *Constantinople: City of the World's Desire, 1453-1924* by Philip Mansel; *Architecture, Ceremonial and Power: the Topkapi Palace in the Fifteenth and*

Sixteenth Centuries by Gülru Necipoğlu; *Byzantium, the Decline and Fall* by John Julius Norwich; "El Gran Turco: Mehmed the Conqueror as a Patron of the Arts of Christendom" by Julian Raby (D.Phil. thesis, Oxford, 1980); *The Fall of Constantinople, 1453* by Steven Runciman; 'Gentile Bellini and Constantinople' by James Byam Shaw in *Apollo*, ns 120, July 1984; *Gentile Bellini et Sultan Mohammed II* by Louis Thuasne; *The History of Mehmed the Conqueror* by Tursun Bey; *The Birth of the Despot: Venice and the Sublime Porte* by Lucette Valensi; and Vasari's *The Lives of the Artists*.

"Man in an Oriental Costume": The painting mentioned in the poem is by Rembrandt, c. 1635, National Gallery of Art, Washington, D.C.

"The Alexander Sarcophagus": c. 320 B.C., Istanbul Archaeological Museum.

"Catalogue": Italicized sections are from a letter by a Turkish soldier, on display at the Kabatepe Museum on the Gallipoli peninsula.

"Index Islamicus": Italicized phrases are "descriptors" for the country of Turkey from the *Index Islamicus*, an annual which indexes literature on Islam, the Middle East and the Muslim world, dating back to 1906.